IMAGES
of America

SAN FRANCISCO'S
MARINA DISTRICT

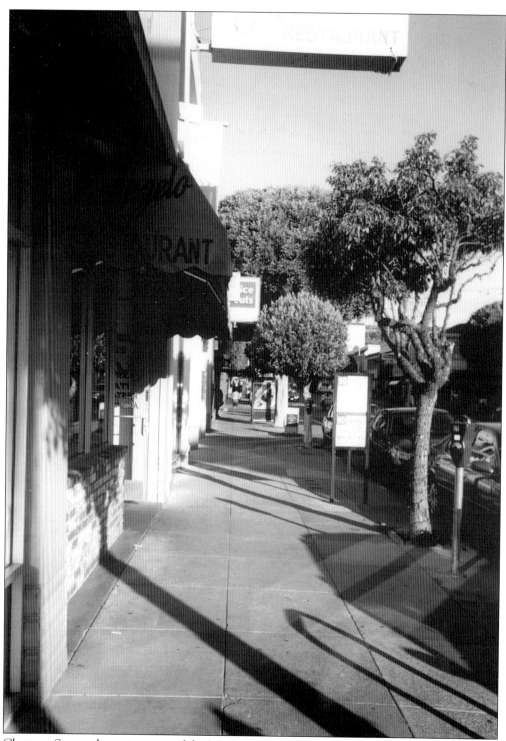

Chestnut Street, the main street of the Marina District, has welcomed residents and visitors to its shops and services for more than 100 years. No one strolling on its sidewalks can fail to find the vibrant and welcoming personality of the neighborhood.

IMAGES
of America

SAN FRANCISCO'S
MARINA DISTRICT

Dr. William Lipsky

ARCADIA

Published by Arcadia Publishing
Charleston SC, Chicago IL, Portsmouth NH, San Francisco CA

Printed in Great Britain

Library of Congress Catalog Card Number: 2004100468

For all general information contact Arcadia Publishing at:
Telephone 843-853-2070
Fax 843-853-0044
E-Mail sales@arcadiapublishing.com
For customer service and orders:
Toll-Free 1-888-313-2665

Visit us on the internet at http://www.arcadiapublishing.com

For Don, Janet, Rick, Jan, Jerry, ZaZa, Joey, and Hillary Rodham Kitten.

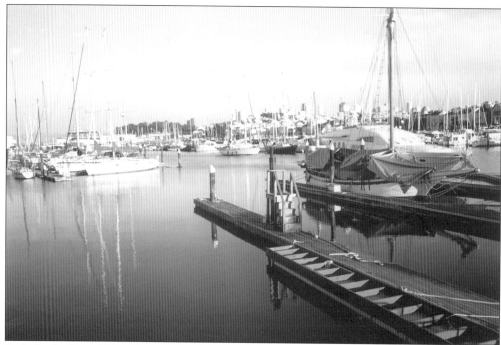

Built for the Panama-Pacific International Exposition (PPIE), the Marina District's Yacht Harbor was a gift to San Francisco from the fair. Its first grand event was the City's celebration of Columbus Day in 1914, four months before the fair itself opened. Today it is every bit as busy as it was then.

CONTENTS

Acknowledgments 6

Introduction 7

1. Sand Dunes and Salt Marshes 9

2. Tragedy and Truimph 41

3. The City of Domes 67

4. A New Neighborhood 105

ACKNOWLEDGMENTS

The image on page 45 (*top*) is courtesy of the National Park Service, Golden Gate National Recreation Area, Park Archives, and is used with kind permission.

The images on pages 29 (*bottom*) and 30 (*top*) are courtesy of the San Francisco Maritime National Historical Park and are used with kind permission.

The images on pages 26 (*bottom*), 27, 30 (*top*), 31, 59 (*top*), 61 (*bottom*), 106, 107 (*top*), 108 (*bottom*), 109 (*top*), 110 (*bottom*), and 111 (*top*) are in the collection of the San Francisco History Center, San Francisco Public Library, and are used with kind permission.

The images on pages 2, 4, 6, 8, 127, and 128 are courtesy of Donald Price and are used with kind permission.

The image on page 36 (*bottom*) appears here for the first time.

Fort Mason, Alcatraz, the Palace of Fine Arts, the Golden Gate and its bridge, the Marin Headlands—the Marina District commands beautiful and spectacular views of the near and distant shores, among the most exquisite and romantic in the world.

Introduction

The neighborhood we know as the Marina District is a modern marvel. Not only did its homes, stores, and streets not exist a hundred years ago, neither did much of the land upon which they are built. Only the spectacular views were there from the beginning.

We owe President Millard Fillmore a word or two of thanks for the neighborhood. In 1850, when California became a state, he exempted the sand dunes and salt marshes between the Presidio and Black Point—now Fort Mason—from both state and city jurisdiction. The entire tract became unavailable for either public or private purpose.

The following year, Fillmore divided the north shore's federal lands into two parcels. One extended from what is now Lyon Street west to the Pacific Ocean. The other ran east from what is now Laguna Street to Black Point. Fillmore returned the tract in between the parcels to the State of California. San Francisco took the high ground, and the state claimed exclusive jurisdiction over the tidewater and submerged lots.

Sometimes the smallest detail makes the biggest difference. Because of Fillmore's decisions, the north shore's submerged lots came under the jurisdiction of the State Tide Lands Commission, not the State Board of Harbor Commissioners, and as such were excluded from plans for the Port of San Francisco's development. Separated from the rest of the City's shipping industry by Black Point to the east, the area was used mostly by small entrepreneurs. This made sense because of the limited amount of land available. Developers were unable to use the shoreline to the west because of the Presidio, and unable to build into the Bay.

The state began selling its north shore lots to private owners in 1864. The first sale, some 448 acres, at $1 per acre, was to the Northern California Homestead and Railroad Association. The organization made no use of its new property, which was bordered by the Presidio, Lombard, Webster, and Tonquin (now Marina Boulevard). However, no one else could use it either, which further stalled development. The state sold the rest of its title to the north shore's tidelands at public auction in 1873—ten blocks of submerged lots north of Tonquin.

Relatively remote from the rest of San Francisco, the north shore developed slowly, a place of dairies, truck farms, crab fishers, road houses, and resorts. No serious effort at development took place until the 1880s, when James Fair decided to create an industrial district out of 21 blocks of shoreline property and 15 blocks of submerged lands. His death in 1894 ended the project, but by then heavy industry had begun moving into the district.

Three events ended the industrialization of the north shore: the seemingly endless probate of James Fair's will, the Great Earthquake and Fire of 1906, and the 1915 Panama-Pacific International Exposition (PPIE). The first prevented development of more than 70 acres of real estate, the largest private parcel. The second turned San Francisco to rebuilding, not expansion. The third created a flat, empty tract of land perfect for subdivision into a residential neighborhood.

In 1924, Virginia Fair Vanderbilt, with clear title to 55 acres of her father's north shore land, sold her property to the Marina Corporation, a consortium of San Francisco builders and developers. The new owners called their project—bordered by Marina Boulevard, Scott, Chestnut, and Fillmore Streets—Marina Gardens. Like earlier attempts to change the name of

the neighborhood to names like Golden Gate Valley and Exposition Valley the designation didn't stick. The area became, simply, the Marina District.

The Marina Corporation hired architects Chesley Bonstell and Mark Daniels to create a master plan for the Marina-Vanderbilt tract. The pair proposed a neighborhood of one acre and 1.5 acre estates, surrounded by lawns and gardens, fronting streets laid out in a non-traditional grid pattern; a grand boulevard would end at the Palace of Fine Arts, making it the Marina's Arc de Triomphe.

The architects' proposals were never entirely implemented, partly because landlords west of Scott Street weren't included in the plan, and partly because many buyers subdivided their property, then put up apartment buildings instead of single family homes. Portions of the street plan survived on the Vanderbilt tract, but a traditional grid pattern was used for the rest of the neighborhood.

In the end, it really didn't matter. As it developed, the new neighborhood emerged as if it were entirely planned, a singularity of style and surroundings, completely unique, and completely San Francisco.

Built in 1915 for the Panama-Pacific Exposition, Bernard Meybeck's Palace of Fine Arts immediately became and has since remained one of San Francisco's most beloved landmarks. Designed to evoke the romance of ancient ruins, it gradually became its own "neglected spot" in the salt air and fog. It was rebuilt in the 1960s.

One

SAND DUNES AND SALT MARSHES

When they arrived some 4,500 or more years ago, the Coast Miwoks or Costanoans, the Bay Area's first residents, found the upper San Francisco peninsula to be a place of sand dunes and salt marshes, bogs and bullrushes, fog, wind, and steep hills. The waters of the shoreline provided excellent seafood, and inland there was game such as birds, deer, and elk. However, the land wasn't a particularly warm or comforting place to be.

The Coast Miwoks had all of San Francisco to themselves until 1769, when the first Spanish settlers arrived. The newcomers built a fort and a mission—a town never took root—then converted and subjugated their predecessors. Because they were few in number, the land remained very much as they found it.

During an era of European imperial expansion, no one seemed to care much about California. First Spain and then Mexico ruled it nominally, settled it sparsely, and visited it rarely. Certainly no one cared about San Francisco, which could take a traveler from Madrid four months to reach. News of Mexico's independence arrived at the Presidio a year after it happened, partly because it seemed unimportant that anyone there be notified.

Once they acquired California in 1848, the Americans generated interest almost immediately. Six weeks after Mexico ceded California (and much more) to the United States in the Treaty of Guadalupe Hidalgo, a San Francisco newspaper printed the first account of James Marshall's discovery of gold at John Sutter's mill near Sacramento. Although the north shore would remain essentially rural for many more years, the rush was on to build a city by the bay.

The Coast Miwoks, or Costonoans, became the first people to visit what is now San Francisco about 2,000–2,500 BC. Unlike the Europeans some 3.5 millennia later, they had the good sense not to tell the rest of the world about their discovery, enjoying the Bay Area without traffic or tourists. Louis Choris's portrait conveys some small sense of the people and their culture.

The Miwoks had their territory to themselves until 1769, when Gaspar de Portola headed a land expedition into upper California to collect information about possible sites for colonial settlements. A lead party commanded by Jose Ortega reached San Francisco Bay on November 2. Unable to cross the Golden Gate, the journey ended with Ortega cursing his bad luck for stumbling upon the world's greatest natural harbor.

The Spanish returned in 1775, this time by sea. On August 5, captained by Juan Bautista de Ayala, the packet ship *San Carlos* became the first known European vessel to sail into San Francisco Bay. For the next six weeks, chief pilot Jose de Canizares mapped the area, and his maps greatly assisted the settlers who arrived the next year.

A year later, an assembly of Spanish soldiers, missionaries, and settlers led by Juan Bautista de Anza came to colonize California at the Golden Gate. They reached San Francisco Bay on July 27, 1776.

Whatever else you might say about them, the Spanish recognized a good location when they saw it. They founded a military post at Laguna del Presidio, a civilian pueblo nearby, and a religious enclave to the southeast. They then set about converting the Miwoks to Christianity and peasantry. Choris's seemingly idyllic rendering of the Presidio in fact shows mounted Spanish lancers herding Native Americans who had possibly quit the confines of the Mission.

When Capt. George Vancouver visited San Francisco Bay in 1792, he harbored in a small cove about a mile from the Presidio, marked with a rectangle on his map. Had the north shore been better suited for his ship and those that followed, San Francisco might have begun at the Marina Green, not Yerba Buena Cove. Vancouver wasn't impressed with the location.

William Richardson reached San Francisco in 1822. Unlike Vancouver, he was very impressed. Despite a ban against foreign immigrants, he got permission to stay. In 1835, he received the grant of a lot about 750 yards southwest of the anchorage at Yerba Buena Cove, now part of the 800 block of Grant Avenue, where he built a house and store. First Yerba Buena village, and later San Francisco itself grew from there.

While Spain and Mexico ruled California, servants took the Presidio's laundry to a small freshwater lake known as Laguna Pequena, among the north shore's sand dunes a few miles east of the fort. When they had enough wash to justify the journey, they would pile it into a carreta and leave for the lagoon. Depending upon the quantity, it might be several days before they returned home.

After the discovery of gold in 1848, San Francisco grew prodigiously—one reason clearly illustrated in a contemporary British magazine. Most newcomers settled close to Yerba Buena Cove. Being outside the city limits, Laguna Pequena—its name now changed to Washerwoman's Lagoon by the Americans—was not even on the earliest survey maps. A few enterprises established themselves there, but it remained sparsely populated and essentially rural.

The Gold Rush caused the cost of cleaning garments in San Francisco to exceed their worth; the fastidious few found it less exorbitant to send their linens abroad to be washed. Those who did laundry locally favored Washerwoman's Lagoon. The women worked on one side of the lagoon, washermen on the other. These fellows, mostly former and future miners, made laundering an earnest enterprise, using large cauldrons to boil clothes clean and washboards to

scrub them. Looking west, the lagoon lies at the center of Carlton Watkin's 1858 photograph. The house in the foreground belonged to the Loveland family. On the left is Old Presidio Road, and Strawberry Island, its northern tip approximately the intersection of Baker and Beach, is on the upper right.

When San Francisco finally had housewives, some journeyed to the lagoon on Sunday to do their family's laundry themselves. They often made an outing of it, taking cloth and kin—and a picnic lunch. Once laundered, the clothes were draped on the chaparral and scrub brush to dry. As wool can't be washed, our ancestors were seldom as unsullied as their portraits present.

Chinese immigrants eventually became the washermen and women at the lagoon. Prejudice had forced them out of the gold country, but laundry didn't discriminate and required little capital or equipment. By the end of the decade, however, two large commercial laundries had built plants near the little lake: Ansel and Easton's Steam Laundry; and Laidley's Occidental Laundry Company.

Washerwoman's Lagoon served for many years, but its water became so corrupt that in 1877 prisoners from the City jail filled it with sand from neighboring dunes. By then San Francisco's housewives had the means to do their laundry elsewhere. Our portrait of an energetic homemaker, conceivably, could be titled, "At liberty, frightening the world." Franklin, Filbert, Octavia, and Chestnut Streets mark the approximate boundaries of the old lake.

In its first years, San Francisco had about as much fresh water as it had fresh linen. There wasn't a water works, so drinking water was delivered door to door, a "bit" for a bucket. Steiner Street, which runs north into the Marina District, was named for one of the water carriers.

In 1852, the Mountain Lake Company began constructing San Francisco's water system. It tunneled into the hills around Mountain Lake, then built a flume across the north shore and around Black Point, shown here. It discovered too late that its outlet was higher than its source, but the neighborhood children got a dark, dank tunnel to explore, had they but the candles and the courage. Five years later, the San Francisco Water Works succeeded.

The land near Washerwoman's Lagoon attracted vegetable farmers. Beginning in the 1850s, the area became an important suburban produce district. Windmills brought water to the surface for irrigation. This garden, cultivated by Chinese c. 1885, was near Union and Pierce.

When Robinson & Snow published their bird's-eye view of San Francisco in 1864, the land between Black Point and the Presidio was still essentially rural. Although some existed only on paper, there had been some discussion to rename many of the streets west of Larkin. Had it happened, Gough would have been changed to Lafayette; Octavia to Jefferson; Laguna to Clinton; Buchanan to Monroe; Steiner to Madison; and Pierce to Hamilton. The map clearly shows the Bay Shore and Fort Point Roads traversing the sand dunes and marshlands between North Beach and the Presidio. The large factory on the north shore is the Pioneer Woolen Mills, which opened in the 1850s and closed during the 1890s. Fort Mason is just northwest of the mills; Gas House Cove is west of the fort. Between the Cove to the Presidio, most settlement is along the Old Presidio Road. The Golden Gate is marked by the flag flying from Fort Point in the distance.

The Hatman family started the neighborhood's first dairy farm in 1861, on land, purchased for $500, adjacent to Washerwoman's Lagoon. There was some grazing to the west, a few structures, lots of sand dunes, and very little else. In ten years, more than 30 dairies thrived between Van Ness Avenue and the Presidio, averaging 60 cows each. The Matthias family had a milk ranch at what is now the intersection of Steiner and Francisco. Nearby were the herds of E.K. Knight, at Lombard and Steiner; and Frank Emhoff, at Lombard and Pierce. By the middle 1870s, more than a dozen dairies were located near the north shore. Among others, Charles Chase was at Baker and Beach; Joseph Bulletto, George Fruhline, and Louis Miller were all on Chestnut between Scott and Divisadero; Nicholas Lassans was on Chestnut between Divisidero and Broderick; Adolph Lorenz on Beach between Broderick and Baker; and George Mathias on Francisco between Pierce and Steiner.

With livestock came meat packing. The area around Chestnut and Polk, known for a time as Butchertown, occasioned a new sport for neighborhood children: turtle sledding. Large green turtles were brought up from Mexico, their meat prepared and sold locally. The discarded shells were wide enough for grade schoolers to sit in. They dug gullies into the sand, slicked the surfaces with water, then sledded down the dunes into the water.

Tanneries typically follow packing plants. Possibly the earliest at Harbor View, established in the 1850s, was M.M. Cook's Tannery on Old Presidio Road, which emptied its brown tanbark into Washerwoman's Lagoon. Also on Presidio Road was H. Von Seggeren's Tannery. McKenna, Tunstead and Ryan, which opened during the 1870s, operated nearby on Greenwich near Octavia. By 1880, all the tanneries had left the neighborhood.

Crabville was the name given to the crab-fishing community at Harbor View, which had its own wharf near what now is the intersection of Majorca and Toledo. Using the leftovers from nearby packing houses for bait, the crabbers lowered their nets, set their trap, and gathered their prey in the waters between Black Point and the Golden Gate.

Crab was so abundant, observed the *Overland Monthly*, that "many a penniless old drunkard or tramp may be seen on a pleasant day sunning himself on a pile on the northern shore . . . while he waits for crabs to crawl into his nets. After boiling his morning's catch over a fire of driftwood, the whisky-soaked old human driftwood peddles his wares around the neighborhood."

OLD SPORTS

Barred from numerous opportunities by prejudice, covenant, and legislation, many Chinese immigrants turned to fishing for their livelihood. By the end of the 19th century, they operated more than two dozen "shrimp camps" on San Francisco Bay. Each camp worked a particular portion of the waters, which all the others honored. The shrimp junks added a gracious touch to the endeavors.

Distillers established themselves in the neighborhood. The Pacific Distilling and Refining Company, at Chestnut and Pierce, was only one of many in San Francisco during the latter part of the 19th century. Many of them were located south of Market, but some opened for business in North Beach and Harbor View.

South of Washerwoman's Lagoon was a small inlet that came to be known as Gas House Cove, where barges, left, docked and unloaded mostly Australian coal to be turned into gas. During the 1870s, the San Francisco Gas Light Company built a large plant and storage facility near Fillmore and Chestnut. It opened a second works on Bay between Laguna and Webster in 1891; its gasometer, or storage holder, was then the largest west of Chicago.

Because of its remoteness, the north shore became a destination of sorts. By 1854, Sylvester Mowry had opened perhaps the district's first tavern, followed by Nathaniel Brooks. Then Douglas Knight then began the El Dorado House on Lombard near Broderick; and Frederick Weisenborn opened the Presidio House nearby on Lyon. In those days, ladies favored rich and decorated clothing; creased pant legs for gentlemen were still 50 years in the future.

The largest and grandest destination was owned by Rudolph Herman. Born in Brunswick, Germany in 1831, Herman came to San Francisco in January 1854. After a series of jobs, he opened a bath house in North Beach in 1860. Two years later, he moved to the area he called Harbor View, which ultimately became the name of the entire waterfront between Black Point and the Presidio.

When Herman moved to the north shore in 1862, it was almost entirely sand dunes and salt marshes, with few residents or roads. Unconcerned, in 1864, the year he wed Mary Minkel, he opened Harbor View House on land near the north end of Baker Street. Partly because of the vegetation and partly because of the tides, the site alternately was called Strawberry Point, Sand Point, and Strawberry Island.

HARBOR VIEW PARK,

Is situated directly on the Bay shore, in the northwestern part of the city, adjoining the Presidio Government Reservation, and is accessible from the city front by horse cars to the junction of Montgomery Avenue and Montgomery Street, thence by the Union-Street Line of Cable Cars, which pass the Park and Hotel, situated on Jefferson Street bet Baker and the Government Reservation. This beautiful place of resort was founded by R. HERMAN, Esq., over twenty years ago, is one of the most popular suburban, health and pleasure resorts of San Francisco. The grounds comprising three blocks, situated about two miles from the heart of the city, immediately on the shores of the beautiful harbor of San Francisco, commanding its finest views, have by the expenditure of tens of thousands of dollars, and the skill of the artisan and landscape gardeners been converted into

A Perfect Fairy Land

Of green lawn, pleasant walks, arbors and drives, shaded by handsome growths of Monterey cypress, pine, accacia, blue gum, pepper and other evergreens. Here excellent

Garden Concerts,

Splendid orchestral and band music, social hops, boat racing, prize swimming and shooting, fine hot sea baths with the purest of ocean water, excellent surf bathing, etc.

The Pavilion

Is a magnificent structure, 130 feet in diameter, with a roof supported by a single central pillar, a dancing floor unsurpassed on the coast, and ceilings artisically decorated in excellent imitation of living trailing vines, plants and flowers.

The Bathing Facilities

Are among the most complete on this coast. The beach for surf bathing is splendid smooth, free from stones, and perfectly safe at all times. There are a large number of separate bathing apartments, with suits, towels, etc., under the careful supervision of a constant attendant. The sanitary regulations are excellent, and the whole place is kept in the most perfect order. The accommodations for

HOT SEA BATHS

Are unexcelled. The sea water comes direct through the Golden Gate from the ocean, and is pumped into large tanks, where it is heated by steam, and then drawn off into the different neat and commodious bathrooms. You can visit

HARBOR VIEW PARK

The CONEY ISLAND of SAN FRANCISCO

Herman gradually expanded his business, adding a shooting gallery, a large hotel, a restaurant, picnic gardens, a complete system of hot and cold salt water baths, changing rooms for whoever wished to swim in the bay, and two wharves. The compound, now called Harbor View Park, stretched along three blocks. The neighborhood that grew up nearby took its name from his establishment.

One of Harbor View's principle attractions was the seafood restaurant run by Louis Swartz. It became well known for its clam chowder, cracked crab, and steam beer "drawn slowly from huge kegs so that the froth permeated every drop." His son operated the establishment until it closed in 1912 to make way for the PPIE.

26

By 1890, Harbor View Park was the north shore's largest resort, famed for its moonlight picnics and "world-renown" hot salt water baths in zinc tubs, "the finest on the Coast." Patrons said the soaks cured everything from rheumatism to hangover; many of these maladies originated elsewhere on the grounds. The dressing rooms for the hot sea baths are on the right, those for the surf baths on the left.

Harbor View Park hosted numerous special events, where patrons could picnic in the gardens or in a gazebo like this one. The grounds closed after the 1906 earthquake, when they were used for a refugee camp. The baths survived another six years, until razed to make way for the Panama-Pacific Exposition. The Palace of Fine Arts stands near the site that welcomed three generations of San Franciscans.

Other entrepreneurs followed Herman to Harbor View. The Winter Garden, a dance hall, opened on Baker near Beach in the 1870s, when this photograph was taken. Seaside Gardens, at Baker and North Point, offered *Punch and Judy* shows and other entertainments. Germania Gardens, at Baker and Jefferson, hosted family picnics. McLane's Crab House, at the foot of Fillmore Street, was favored by the men who worked in the nearby gas works.

Eventually heavy industry moved into the area, although Harbor View never became thick with factories. An early arrival was the Phelps Manufacturing Company at Fillmore, Bay, and Buchanan; it turned to heavy forging in 1882. The San Francisco Gas and Light Company was its next door neighbor. The site, known as Gas House Cove, is in the foreground. Fort Point guards the Golden Gate in the background.

The Fulton Iron Works moved its plant from South of Market to Broderick and Lewis, Harbor View, in 1893. It produced furnaces, boilers, heaters, mining machinery, and eventually ships. In an age when belching smokestacks signified prosperity, not pollution, the company proudly portrayed them operating at full measure.

The risk of fire at any foundry is great, and luck ran out for the Fulton Iron Works in 1902. Fortunately the rescue team from the Life Saving Station near Fort Point was able to offer assistance.

The Fulton Iron Works was one of the businesses forced out of Harbor View to make way for the Panama-Pacific Exposition. Its buildings were too large to move, so everything was pulled down. The area's other shipbuilder, W.F. Stone, founded in 1899 at the foot of Baker, relocated to Oakland in 1912 for the same reason.

Where factories and jobs go, support businesses follow. The Garfield Hotel opened in the1880s at Chestnut and Fillmore. The Jefferson Hotel, at Broderick and Jefferson, followed in the 1890s, primarily to house employees of the iron works and ship yard; both closed when the factories left in 1912. The Hoffman House at Broderick and Tonquin, like much else in the neighborhood, was purchased by the Panama-Pacific Exposition.

There was more between the Palace and the Golden Gate hotels than a nickel streetcar ride. Located at 1619 Tonquin, it offered rooms with or without board, 25¢ meals, and Jackson Steam Beer. The establishment was also purchased by the Exposition.

Ernst Maaka's eatery on the southeast corner of Jefferson and Baker offered clam chowder, sandwiches, beer, ale, and other refreshments. What so intently occupies the three men on the corner isn't now known, but given the lack of traffic, the photograph may have been taken after the property was purchased by the Exposition. Everything—buildings, telephone poles, street lamps, fire plug, and streets—soon would be removed.

"COW HOLLOW"

AND ITS CONDEMNATION BY THE BOARD
OF HEATLH,

AS PUBLISHED IN THE OFFICIAL ORGAN OF THE CITY
GOVERNMENT.

The *Daily Report* article of June '17th, 1890, is reproduced *verbatim* on the following pages, and deserves a careful perusal by every one, not only on account of the few dairies condemned, but because many other dairies supplying this city with milk are equally deserving the attention of the Board of Health, not only by reason of the condition of their cows, but because of the unwholesome food fed them that is strictly forbidden by law.

MILK.

WHOLESOME FOOD OR DEADLY POISON, AS MAY BE
SOME HEALTH OFFICE DISCOVERIES THAT WILL
MAKE OUR MILK DRINKERS SHUDDER THE HOR-
RORS OF "COW HOLLOW" INVESTIGATED THIS
WEEK BY THE HEALTH OFFICIALS—DR. McQUES-
TEN REPORTS FULLY—THE BOARD WILL DEMAND.
THE SLAUGHTER OF ALL DISEASED COWS AND A
THOROUGH INSPECTION HEREAFTER.

In 1891 the City banished the cows. "If some one were to start out and search California from end to end, they could hardly find a more unsuitable place in which to keep cows," stated one health department officer. By order of the board of health, the cows moved elsewhere.

Getting to Harbor View wasn't all that easy during the early days. People walked, rode horseback, or used their own buckboards or carriages. The first public transportation was a stage line that began at Portsmouth Square, traveled out Pacific Street to Larkin, then journeyed over the Presidio Toll Road to Francisco and Fillmore. From there, the stage went up to Harbor View before entering the Presidio.

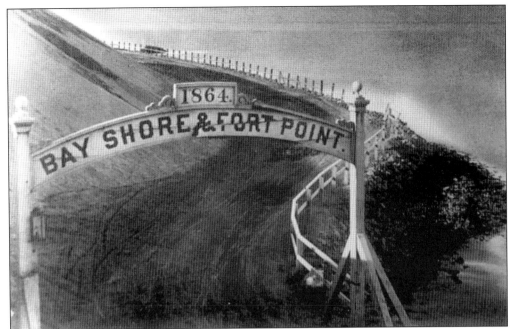

In 1861, the Bay Shore and Fort Point Road Company received permission from the state legislature to build a macadamized roadway along the north shoreline. Beginning in North Beach, it eventually reached the Presidio near what is now the Marina Gate. The photograph of the toll gate at Bay and Jones is from a Lawrence and Houseworth stereoview card.

An omnibus service between North Beach and Harbor View started in the late 1850s, but there was no streetcar service to the area until May 1, 1866, when Henry Casebolt's City Front, Mission and Ocean Railroad began operation. Its horsecars—this one ran on Market Street—traveled outbound on Sutter to Polk, then north to Broadway. From there a branch line zigzagged west and north to Herman's hotel.

Beginning on September 1, 1874, The City Front Railroad featured San Francisco's other cherished contribution to human transport: Casebolt's amazing "balloon" cars, which reversed direction without turntable or switchback. The passenger compartment was mounted on a pivot above its supporting undercarriage, which let the driver turn it 180 degrees, then lead the horses, without unhitching them, in a semi-circle to face the opposite direction.

The "balloon" cars didn't stay in service very long. The pivots wore badly, making the passenger compartments sway and the riders seasick. The cars also had the unhappy habit of departing the track at inopportune times. Upon retirement, two of them became stationary tea rooms at Harbor View Park. They were demolished to make way for the Exposition, but Casebolt's home in neighboring Cow Hollow, built in 1866, still stands.

The City Front Railroad began its conversion from horse to cable power in January 1877. The same year, on September 22, it initiated service on San Francisco's first steam railway, which ran from the company's outer terminal at Polk and Broadway to Harbor View Park, where this morning train has just unloaded its passengers. In November 1879, the organization changed its name to the Sutter Street Railroad.

The Presidio & Ferries Railroad began operating cable cars on Union Street on October 23, 1880. The next year, it bought the money-losing steam railway. To connect its two lines, the new owners moved the steam line's inner terminal, first to Union and Steiner, then in 1892 to Baker and Greenwich.

An extension of the Union Street route into Presidio during the 1880s finally made the steam railway profitable, but the Great Earthquake of 1906, which destroyed most of its track, marked the end of the line; it was never rebuilt. The equipment seen here, resting at Harbor View Park, was fabricated locally.

Public transit started on Fillmore Street in 1895. For most of its route, the line ran on electricity, but between Green and Broadway, it used cable. It had the only rolling stock in San Francisco that could work with two different types of power.

The Fillmore line used a unique counterbalance system on the cable portion of its route, the northbound car pulling the southbound car up as it traveled downhill. A heavily weighted dummy helped the day's last passenger car make the climb; the next morning's first northbound car pulled it back up. During the wee hours, a lantern warned motorists, sometimes without success, of the mass of metal in the intersection of Fillmore and Green.

It was the Fillmore Street Hill's 24-percent grade that made cable—and wooden stepped sidewalks—necessary. In 1941, when the counterbalance was discontinued, Broadway became the end of the line; motor coaches made the journey from there to and from Marina Boulevard. Buses replaced the streetcars on the rest of the route in 1948.

When San Francisco celebrated the centennial of American independence in 1876, it did so in a big way. In addition to the usual and expected parades, orations, and patriotic hymns, celebrants stated a sham battle at Harbor View. The future Marina District is seen here as the flats between the hills and the bay.

During the 1870s and 1880s, San Franciscans also celebrated Independence Day with grand regattas that included everything from enormous barkentines to tiny sloops. The Master Mariners' Benevolent Association was the official sponsor, its champion's banner the grand prize. Here the schooner *General Banning* turns to complete the course from the Presidio to North Beach, its 38-star flag indicating a race before 1889. Harbor View provided an excellent prospect.

Beginning in the 1880s, San Francisco nabob James "Slippery Jim" Fair began buying large parcels of property in Harbor View. He planned to fill 15 blocks of submerged lots, then develop them and 21 blocks of shoreline into a district for factories and warehouses. Unfortunately for his project, he died in 1894, before it could be realized. Only a seawall along the northern boundary of his holdings was completed.

Litigation surrounding probate of Fair's will prevented industrialization of his Harbor View property for many years. Although his daughters eventually received clear title, they had no interest in pursuing their father's project—or in selling the land. At the 19th century's end, the area, seen here from Fort Point, still seemed destined to be yet another bayfront manufacturing district, but within 15 years, all the factories were gone, never to return.

"UNDAUNTED" San Francisco, shot in the back and badly wounded, rose above the devastation of the Great Earthquake and Fire of 1906. The fanciful design of the PPIE on this early booster card bore no resemblance to the actual layout of the fairgrounds or to Harbor View, where it would be held, but it graphically conveyed the great city's determination to overcome adversity.

Two
TRAGEDY AND TRIUMPH

In 1904, at the height of world's fair fever in the United States, local merchant Reuben Hale proposed that San Francisco host a grand exhibition to celebrate the completion of a Great Canal across the Isthmus of Panama, the engineering feat of his generation. Many residents, who fondly remembered the Midwinter Exposition held ten years earlier, liked the idea.

Hale's idea was both astute and audacious—astute because the project could generate more than $50 million for the local economy, establish San Francisco as the hub of Pacific commerce, and solidify the City's position as the capitol of the Western states; audacious because the Panama Canal was not yet underway.

When Hale made his proposal, the United States hadn't received permission from the new nation of Panama to construct a canal through their territory, although no one doubted that permission would be granted. Not one shovelful of dirt had been taken, and not one page of blueprints had been drawn. No commencement or completion dates had been established. Worse, the previous effort on the Isthmus, led by Ferdinand De Lesseps, who built the Suez Canal, ended in failure in 1899, just five years earlier. The project lost $300 million in an era when a daily newspaper cost 3¢. No one knew when, how or if the next attempt would be successful.

Before anyone had a chance to find out, the Great Earthquake and Fire of 1906 seemed to put an end to San Francisco's dream of hosting an international exposition—and a lot more as well. Unfortunately but understandably, a grand international exposition became the last item on every agenda.

In the first years of the new century, public transportation reigned supreme in San Francisco. Horse, cable, and electric cars operated on miles of track. Automobiles, a new and noisome contrivance, simply couldn't climb the City's hills, although owners could choose among electric, steam, or gasoline engines. Some saw the possibilities, however, crafting this stately electric hansom for elegant transport to notable occasions.

The night before the earthquake, celebrated tenor Enrico Caruso sang the role of Don Jose in *Carmen* at the Grand Opera House. When disaster struck, say the stories, he fled the Palace Hotel, a warm towel wrapped around his sensitive throat. Famed photographer Arnold Genthe heard him vow, "I never come back here." Caruso eventually changed his mind, but died before he could return.

The San Francisco Earthquake and Fire was the greatest natural disaster in American history. What the quake didn't reduce to rubble, the flames incinerated. Unknown thousands were dead and tens of thousand were homeless, the entire business district and the civic center were destroyed, and the infrastructure decimated. The situation was more the ruin *of* San Francisco than the ruin *in* San Francisco. Alma Crowley's song was only one of many written about it.

People fled the city's wreckage using any means they could find. The fortunate still had carriages or wagons at their disposal, and still had some possessions to move in them. Some used handcarts, wheelbarrows, toy wagons, or strollers. For many, including some of these refugees traveling west on Lombard to the safety of Fort Mason, Harbor View, or the Presidio (or possibly to emergency shelters in the East Bay), their sole transportation was their feet, their sole possessions their lives and the clothes they wore.

Although the tracks on nearby Union Street were destroyed, Harbor View itself sustained relatively little damage from the double catastrophe. The gas plant was rendered useless, but the storage tanks in the gasometer held. Water mains burst at Chestnut and Broderick, Lombard and Fillmore, and Lombard and Octavia; fortunately there were no fires nearby.

The north shore became home to four refugee camps. Fort Mason, seen in the foreground, hosted one; Lobos Square, in the background, another; Harbor View Park was home to a third. A fourth extended from Union and Lyon Streets north and west across Presidio land to the Golden Gate. The day after the earthquake, eight San Franciscans were born in the camp at the foot of Van Ness.

Located near Rudolph Herman's resort, the Harbor View Camp acquired the reputation of sheltering the toughest and most difficult group of refugees. Dr. Rene Bine, a 24-year-old local physician, volunteered to supervise the physical necessities. He had the tents arranged along numbered streets, assigned inspectors to calculate the need for clothes and blankets, and made sure everyone got to their meals.

By the beginning of August, the Harbor View Camp housed more than 2,900 people. Fortunately, Dr. Bine had put garbage pails at the end of each row of tents and installed latrines, which were pumped out, disinfected, and cleaned at least twice daily. As refugees found other accommodations, the population dropped over the next five months. The site was abandoned in January 1907.

Many of the people who set up residence in Lobos Square were working families. Unable to rescue most of their belongings, and with few resources, they were provided with clothing and bedding.

When the Army returned control of the Western Addition to local authorities, Lobos Square also became the site of a temporary police station.

The Harbor View Camp closed at the beginning of 1907. Its remaining refugees moved to the nearby Lobos Square Camp, which eventually became a community of substantial cottages.

The Lobos Square camp was a temporary home to many of the city's Japanese residents. They soon became caught up in an international incident when the San Francisco Board of Education decided to send all "Orientals" to segregated schools once new facilities were built. Japan protested to President Theodore Roosevelt, who condemned the board's plan. Eventually, the scheme was dropped.

Chinatown was completely devastated. Most of the city's Chinese residents went to Chinese-only refugee camps in Oakland, but some were garrisoned at the foot of Van Ness or in Golden Gate Park, where police segregated them from other evacuees; the Army soon moved them to a separate camp in the Presidio. Less than a week after the earthquake, a meeting of the San Francisco Real Estate Board recommended permanently relocating the entire Chinese community as far from downtown as possible. Only the Chinese government's vigorous protests eventually ended the attempt. Other individuals were concerned that both Chinese and Japanese residents, having enjoyed living in the tents of Golden Gate Park, Fort Mason, Lobos Square, and the Presidio, now would want to move into the neighborhoods nearby. These fears finally vanished in 1913, when California passed legislation forbidding Japanese and Chinese ownership of land in the state; the statute remained in effect until 1952.

A pass from the governor's office was required to enter San Francisco, but anybody who had legitimate reasons to be within the disaster zone got one easily; several assistants signed them for J.B. Lauck, adjunct general of California. Within the city, meal tickets were available to all who needed them.

As early as 1907, San Francisco proclaimed itself again open for business. "To share my prosperity is the opportunity of your lifetime," declared "The Queen City of the Pacific":

Have you seen fair San Francisco,
'Neath skies of deepest blue,
Which in all fair California—
Is the city fair for you?
Have you seen fair San Francisco,
Where prosperity does smile,
And the Golden Gate stands open
Waiting for you all the while?

According to urban legend, the rubble from the Great Earthquake and Fire was brought to Harbor View and dumped, creating landfill for the upcoming PPIE. This is not actually the case. Whatever couldn't be salvaged was gathered up and taken out of the city by ship and by train. None was hauled across town to the future fairgrounds, which had yet to be selected. In fact, San Francisco wouldn't be awarded the exposition for another five years.

Life in the camps was primitive and luxuries non-existent, but one always finds a way. With a dolly for comfort, a scooter for transportation, and a new adventure every day, these children at the Lobos Square refugee camp seem to have their situation reasonably under control.

When camp life ended in the summer of 1908, many refugees took their cottages with them. Dray horses, hitched to house-moving rigs, did the heavy work; the two boys following behind came along for reasons not apparent. They probably took in a site seldom seem, however. To where this dwelling from Lobos Square was moved—or even if it still exists—is now unknown.

In 1908, the aptly named Great White Fleet visited San Francisco as one port of call on its 14-month-long voyage around the world. Sixteen new battleships, each painted white except for the gilded scroll work of their bows, arrived on May 6 from Magdalena Bay, Baja California, for a month's stay. They were under the command of Adm. Robley "Fighting Bob" Evans, who had

been captain ten years earlier of the first ship to fire the first gun against the Spanish at Santiago. Ranged from Fort Point to Fort Mason, they pass Harbor View (*above*), no doubt exciting thoughts of strength and security among many who had felt neither for two long years. The panorama from Telegraph Hill (*below*) was equally spectacular.

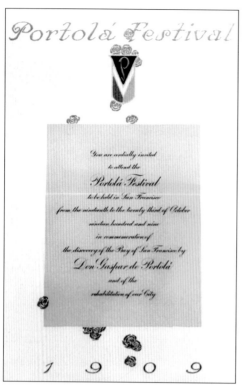

Still rebuilding, San Francisco celebrated its recovery to date in October 1909. The *Portola Festival*, a glorious five-day merriment, showed that "The City that knows how," as President William Taft put it, still knew how to skylark. It also revived the idea of hosting an international exposition, which had faded after the double calamities. Now the fair's boosters decided to pursue their vision seriously.

On December 7, 1909, a public meeting at the Merchants' Exchange ended with the decision to host an exposition celebrating the opening of the Panama Canal. A second meeting on April 28 of the following year raised $4,089,000 in less than two hours. By June, the amount had increased to $6,156,840. San Francisco then sold an exposition bond, adding another $5 million, and the State of California approved a special measure that committed $5 million more.

The formidable task of building the Panama Canal was called "The Thirteenth Labor of Hercules." The demi-god himself appeared on the exposition's official poster, designed by Perham Nahl, pushing apart the continents, making the fairgrounds visible in the background. Those who had (apparently) never before seen an uncovered human backside were suitably scandalized.

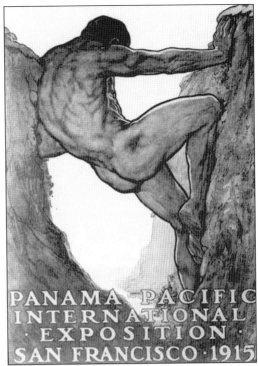

PANAMA·PACIFIC INTERNATIONAL ·EXPOSITION· SAN FRANCISCO·1915

Many cities wanted to host the exposition, so electioneering became enthusiastic. San Franciscans reminded the public of New Orleans's money-losing exhibition of 1884. They generated 2 million postcards to Washington in one week. They vowed to take no subsidy from the federal government, which put them into the lead. Congress awarded San Francisco the honor, and President Taft signed the legislation on February 15, 1911.

Just before they heard that San Francisco would be hosting a world's fair, residents of Harbor View had a preview of the world's wonders to come from aviators attending Northern California's first air meet. On January 5, Hubert Latham piloted the first airplane through the Golden Gate. On January 18, Eugene Ely became the first airman to land and take off from a ship, the U.S.S. *Pennsylvania*, then anchored off the northern waterfront. "When one stops to think that the aeroplane was traveling about forty miles an hours when it touched the deck," wrote aviation pioneer Glenn Curtiss, "the remarkable precision of the aviator will be appreciated." At the same meet, Lt. Myron Crissy dropped the first explosive bomb from an aeroplane onto Selfridge Field (now Tanforan Mall in San Bruno), demonstrating the feasibility of airborne assault—progress indeed. The neighborhood has witnessed other aviation milestones: the first indoor flight in 1914, the first scheduled landing of the Trans-continental Air Mail Service in 1920, and the first public helicopter flight in the Western United States in 1944.

The Exposition's board of directors spent half a year choosing a site. In July 1911 it voted to put parts of the fair in Golden Gate Park, Lincoln Park, the Presidio, and Harbor View. Many months later, it settled on Harbor View alone, the location proposed by board member James McNab, whose home was nearby.

President Taft himself came to San Francisco for the groundbreaking ceremonies held on October 14, 1911. Unfortunately, the exposition's location hadn't yet been decided, so some 100,000 people watched him use a silver shovel to turn the first scoop of sod in Golden Gate Park, one possible locale. A baby ram born on the same day in the park became the fair's mascot. Of course he was named Bill.

The Harbor View site was controversial. Many San Franciscans believed the Exposition was wasting money by leasing or buying and then developing private property, money saved simply by locating the fair elsewhere. Worse, after having spent $50 million, every vestige of the fair would disappear after it ended at still more expense. Not a single shrub would remain for the public's pleasure, although landlords would get back greatly improved property.

The Exposition faced a daunting task working with what Mayor James Rolph called a "waste of mud flats and sand dunes." The solution: simplicity itself. First planners sited the major exhibit halls around three inner courtyards and five forecourts. Then architects designed not the buildings, but the gardens between them. The walls mitigated gusts and gales, while the courtyards provided places for rest and reflection. Engineers designed the rest.

To use the Harbor View site, the Exposition signed agreements with 175 or so different proprietors, some of whom didn't actually own the land. It bought a few parcels, borrowed others, then moved or demolished everything. This included big factories, small businesses such as the Lombardi Wine Company, apartment buildings, homes, and even squatter's cabins. Most of the agreements expired in 1916, and a few in 1917.

With the use agreements signed, engineers repaired the seawall across Harbor View Basin. Then a suction dredge, using a line of 22-inch pipe, brought up fill from the bottom of the bay. The engineers, "quite finicky about the sort of mud they got," maintained a mix of about 70 percent sand and 30 percent sea mud.

Grading followed fill. When completed, the Exposition installed new gas, water, electric, telephone, transportation, and sewer lines. It buried the Sierra and San Francisco Power Company's 11,000-volt overhead circuit under Lobos Square. No attempt was made to keep any of the City's streets that had crossed the property.

Groundbreaking ceremonies took place not only for the fair itself, but for every important structure. When Progressive Party Governor Hiram Johnson spoke at the start of work on the California Building, the exposition's name hadn't quite been finalized. Mayor Rolph, Phoebe Hearst, and Charles Moore, the president of the exposition company, also addressed the crowd.

The Exposition seized every opportunity for publicity. Here the first lumber for the first building (not to be confused with the first lumber for the fairgrounds, an event that was also publicized) arrives at its destination. The delivery was courtesy of the Loop Lumber Company, with the horses and wagon joyously decorated with American flags.

During the fair's construction, a railroad tunnel was built beneath Fort Mason to aid delivery of building supplies and exhibits. When the exposition closed, the track was extended along the north shore to the Presidio. At its greatest extent, during World War II, the State Belt Railroad operated along the entire shore line. By 1990 most of the track north of the Ferry Building was gone.

The large exhibition halls—some the largest structures of their type in the world—were fabricated with steel and wooden frames; inside, no one made any effort to hide or even disguise their framework. Outside walls were covered with a plastic travertine, consisting of gypsum combined with hemp fiber and coloring pigment; it was applied to all the large buildings. The roofs were

covered with imitation tiles. Everything—design, construction, installation, landscaping—was completed in less than four years, and all the while the reconstruction of San Francisco continued. Chestnut Street, above right, was the southern boundary of the Exposition.

While the fair was being built, the grounds were open to anyone who cared to roam them. Admission at first was free, but the company began charging an entrance fee in September 1913. The fee was primarily to discourage overly casual visitors; the gates to the public were closed only for the 40 days before the fair's opening. Hence, final preparations could be completed without the curious and clumsy getting in the way.

When done, the Palace of Machinery became the world's largest wooden building. It had more than eight acres of floor space with two miles of walkways. Inside, more than 2,000 exhibits presented the latest in diesel, steam, gas, and electric engines, their uses demonstrated with pumps, presses, grinders, boilers, and more. Construction, begun in January 1913, was finished in 14 months—almost a year before the Exposition opened.

While it was still being built, San Franciscan Lincoln Beachy, the most famous aviator in the world, took the world's first indoor aeroplane flight through the Palace of Machinery. Although he and his plane struck the far wall at the end of his airborne triumph, both suffered only minor damage.

On Saturday evening, May 2, 1914, nine months before the Exposition opened, some 18,000 San Franciscans celebrated the rebuilding of the City with a "Ball of All Nations" in the Palace of Machinery. Tickets cost $3, which included admission to the fairgrounds. No one now doubted the survival of San Francisco.

Barely 11 years after the Wright Brother's first flight, aviation was such a novel and exciting concept that pilots were bona fide celebrities, avidly sought out by those of earlier eminence. When Medal of Honor winner William "Buffalo Bill" Cody (at right), greeted aeronautics ace Art Smith at the Exposition, they bridged a gap across more than 50 years of adventure.

Three
THE CITY OF DOMES

The Panama-Pacific International Exposition opened to the world on February 20, 1915. Unprecedented among world's fairs, the City of Domes began on time and entirely complete. San Franciscans had followed its planning and construction for the previous five years, attending events, celebrating milestones, visiting the fairgrounds, and wandering through the construction unsupervised, as if each and all were on the board of directors. In a sense, everyone was.

More than any one structure, exhibit, or event, people took to heart the beauty of the fairground itself and its unity of edifice, color, adornment, illumination, landscaping, and purpose—all coming together as one wondrous work. For the first time, an exposition used indirect lighting, hiding bulbs behind cornices, fixtures, and sometimes in the shrubbery.

It mattered not that everything was ephemeral because the greatest exhibit in San Francisco the year of the fair was not at the fairgrounds. It was San Francisco itself, which not for the first time had demonstrated its endurance and ability to arise from the ashes of an apocalypse.

From a vantage point in the Presidio, the Exposition surely seemed a city of stately pleasure domes, an enchanted land on a sunlit shore. The 1915 Maxwell touring car cost $695; a self-starter was $55 extra.

On opening day, Mayor James "Sunny Jim" Rolph led a parade of 150,000 residents and visitors to the fairgrounds; he became so excited he ran part of the way up Van Ness. By the time the multitude reached the main entrance at Scott and Chestnut, shown here, the marching bands and other parade contingents had become completely lost amid the humanity.

To enjoy the fairgrounds cost adults 50¢, or 25¢ for children; military in uniform were admitted without charge. Those with a special opening day admission badge—100,000 sold out in advance—entered immediately. Everyone else bought tickets, used coupons or passes, or dropped coins for the exact amount into a collection box at one of the gateways to the grounds.

Fairgoers who entered along Chestnut passed through one of Golden Gate Park Superintendent John McLaren's most inspired landscapes: a security fence 30 feet high, 1,150 feet long, made not of tall board and barbed wire, but of ice plant. This living rampart—basically flower boxes stacked on their sides—when in bloom, only added to a day's enchantment.

The customs of occasion took place in the great South Gardens where Mayor Rolph and others addressed the assembled. At noon President Woodrow Wilson, in Washington, D.C., pressed a gold telegraph key that sent a signal to an antenna on the Tower of Jewels, which then opened the doors to the exhibition palaces. The great celebration had begun.

**PANAMA-PACIFIC
INTERNATIONAL EXPOSITION
1915**

President Wilson never made it to the Exposition, but Vice President Thomas Marshall did. It was, he said, "as near perfection as the mind and hand of man have ever wrought," although, perhaps, he is better remembered for his comment, "What this country needs is a good 5¢ cigar." Both men appear on this souvenir card printed at the fair by the U.S. Bureau of Engraving and Printing.

Some 255,000 people attended opening day and many of them are seen here listening to opening day speeches. During the first two weeks, more than a million visitors passed through the turnstiles.

Public transportation was ready for the huge attendance. United Railroads extended its #19 line to a new Exposition Terminal at the fair's Van Ness entrance. It also ran four temporary lines to the fairgrounds: #32 from the Southern Pacific Depot; #33 from Twenty-ninth and Mission; #34 from Sutter and Market; and #35 from Carl and Stanyan. These route numbers later went to other lines.

The new Municipal Railway (now called MUNI) built rails to the fairgrounds on both Chestnut and Van Ness. The "F" line ran its first streetcar to Chestnut and Laguna on December 29, 1914. The new "H" line began on August 15, 1914, from Market on Van Ness to Bay; first day dignitaries included City Engineer Michael O'Shaughnessy (below the front middle window) and Mayor Rolph (wearing carnation).

MUNI also created temporary lines for fairgoers. From February to September, 1915, the "G" line ran from Stockton and Market to the Presidio, where it is shown here awaiting its inbound trip. The "I" line traveled from Thirty-third and Geary to Chestnut and Scott, but for three days only—February 20, 21, and 22, 1915. From February 10, 1915 until June 1, 1916, the first "J" operated between Fort Mason and the Embarcadero.

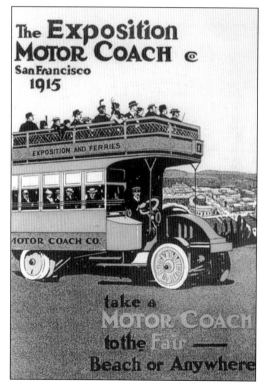

Although the City's transit system brought the vast majority of the Exposition's 18 million visitors, patrons could choose among tour buses, direct ferry service, and automobiles, for which the PPIE, for the first time at a great international exhibition in the United States, provided parking lots.

For many visitors, McLaren's exquisite landscaping was the Exposition's most wonderful display. He had vigorously opposed putting any portion of the fair in Golden Gate Park, but was glad to work amid the sand dunes of Harbor View to transform them with greenery. His glorious South Gardens, seen here, were continuously in bloom, first with daffodils, then with tulips, pansies, begonia, and dahlias.

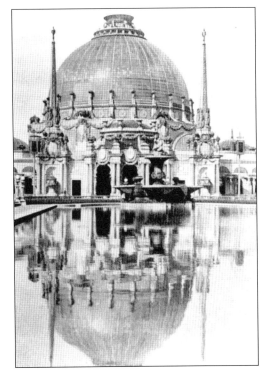

Flanking the South Gardens on its west side was the Palace of Horticulture. It was designed by Bakewell and Brown, who also completed San Francisco's new city hall in 1915.

Festival Hall, on the east side of the South Gardens, became the center of the Exposition's great music festival. Between opening and closing days, there were more than 2,200 concerts; many took place outdoors.

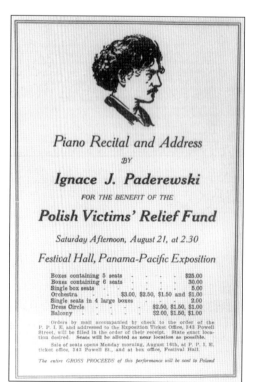

Piano Recital and Address

BY

Ignace J. Paderewski

FOR THE BENEFIT OF THE

Polish Victims' Relief Fund

Saturday Afternoon, August 21, at 2.30

Festival Hall, Panama-Pacific Exposition

Boxes containing 5 seats	$25.00
Boxes containing 6 seats	30.00
Single box seats	5.00
Orchestra	$3.00, $2.50, $1.50 and $1.00
Single seats in 4 large boxes	2.00
Dress Circle	$2.50, $1.50, $1.00
Balcony	$2.00, $1.50, $1.00

Orders by mail accompanied by check to the order of the P. P. I. E. and addressed to the Exposition Ticket Office, 343 Powell Street, will be filled in the order of their receipt. State exact location desired. Seats will be alloted as near location as possible.

Sale of seats opens Monday morning, August 16th, at P. P. I. E. ticket office, 343 Powell St., and at box office, Festival Hall.

The entire GROSS PROCEEDS of this performance will be sent to Poland

Inside Festival Hall, fairgoers could hear pianist Ignace Paderewski, violinist Fritz Kreisler, the Boston Symphony, and contralto Ernestine Schumann-Heink. They could listen to a noon-time organ recital, band concerts, choirs, and choruses.

Schumann-Heink was an unqualified superstar, one of perhaps a dozen artists able to sell out Carnegie Hall. Almost as beloved in San Francisco as Tetrazzini, "the grandest of singers" gave a recital, "exclusively and gratuitously," for 3,000 children in Festival Hall. During the Great War, with sons in both the German and American armies, she tirelessly sold Liberty Bonds and entertained troops in the United States.

The PPIE's 368 organ recitals, performed by Official Organist Wallace Sabin, Edwin Lemare, and others, were greatly popular. When the organ later moved to Exposition Auditorium, the city engaged Lemare as its official organist; his weekly Sunday afternoon organ recitals continued for many years. Badly damaged by the Loma Prieta Earthquake, the organ has been given its third home on the Embarcadero near the Ferry Building.

More than any other single building, the Tower of Jewels, more than 430 feet tall, became the signature structure of the fair. It was decorated with some 100,000 faceted and polished glass stones called "novagems," which were red, green, pale yellow, blue, and other colors. Each one, backed with a tiny mirror, had been individually hung on the building. Swaying in a breeze, the jewels produced a shimmering effect, enhanced at night by indirect lighting. Fog made the building seem even more ethereal.

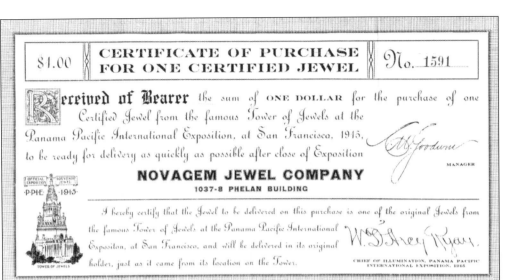

While the exposition was open, fairgoers could buy official, commemorative novagems, copies of the jewels on the Tower of Jewel. Only after it closed could they take possession, for $1 each, of jewels that actually had been on the building. Fortunately, these splendid souvenirs could be reserved beforehand.

Looking north, the Court of the Universe was the heart of the formal exposition. Inspired by the Vatican City's Piazza of St. Peter, the structure had star maidens replacing the saints atop the colonnades. Adolph Weinmann created the figures of *Rising Sun*, right, and *Descending Night*, left, that stood atop the fountains' aerial columns. Many of the fair's ceremonies and concerts took place here, now the intersection of Scott and Beach.

No other world's fair—before or since—commissioned so many original works of art from so many noted masters. Besides Calder, here with his *Star Maiden*, sculptors included James Earle Fraser, Herman McNeal, Gertrude Vanderbilt Whitney, Robert Aitken, Solon Borglum, Chester Beach, Daniel Chester French, Evelyn Longman, John Flanagan, Edith Burroughs, and Paul Manship, among others. Most worked in studios built right on the fairgrounds.

Part of the east colonnade of the Court of the Universe, a colossal grouping, *Nations of the East*, stood atop the Arch of the Rising Sun. It included an Indian prince riding an elephant; a Buddhist lama, "the Mohammedan, with the crescent of Islam"; a Negro slave; a Mongolian warrior; an Arab falconer; a sheik "from the deserts of Arabia"; and "figured types of the great Oriental races."

On opposite side of the court, the grouping on the Arch of the Setting Sun, *Nations of the West*, with a prairie schooner at the center, included figures representing "The Italian immigrant; the Anglo-American; the squaw with her papoose; the horse Indian of the plains; the Teuton pioneer; the Spanish conquistador; the woods Indian of Alaska; and lastly the French Canadian."

In the arcade visitors enjoyed Frank Brangwyn's allegorical murals of *Earth, Air, Fire*, seen here, and *Water*, works now displayed in San Francisco's Herbst Theater. The exposition also commissioned works from Childe Hassam and many others, including local artists Lucia and Arthur Mathews, Florence Lundborg, and Leo Lentelli, whose studio was nearby on Union Street.

At the north entrance to the Court of the Universe, *The Column of Progress*, seen here looking south from the marina, celebrated both civilization's past achievement and its resolve "to go on to still vaster enterprises on behalf of mankind." *The Adventurous Bowman*, progress personified, stood atop the column seeking new empires in the West; he is supported by Humanity, behind him, and by the Woman at his side, ready to crown his success. Sculptor Herman McNeal also designed the United States quarter dollar minted from 1916 to 1930; when some citizens complained because Miss Liberty wore nothing above the waist, the coin was redone to give her breast armor. The column survived the redevelopment of the fairgrounds, but fell victim to the numerous automobiles that collided with it in the 1920s, when its location became the middle of the intersection of Scott Street and Marina Boulevard.

The lawn of the North Gardens was used as an airfield. Lincoln Beachy, the "father of aerobatics," first American to perform a loop-the-loop, tragically was killed when his experimental monoplane, shown here during takeoff, collapsed on itself and fell 500 feet into the Bay. Some wanted to cancel further aerial demonstrations, but they continued with other pilots. A plaque near the entrance to Crissy Field honors Beachy's memory.

Seen from the deck of the U.S.S. *Oregon*, the Exposition seemed an integral part of San Francisco's skyline. The Tower of Jewels was easily the tallest structure on the horizon. The domes of the great exhibition halls were clearly visible, as was the integrated design of the fair's central section.

The Exposition was so immense that no one could hope to see it all, although some claimed they walked every avenue and aisle, which totaled almost 50 miles. Shown here looking east, The Esplanade, now part of Marina Boulevard, was several miles in itself. Visitors spending a mere two minutes at each exhibit would have needed almost a year to see everything—longer if they wanted to include the Zone's attractions.

It may have been necessary to walk within the buildings, but it wasn't necessary to walk between them. The Fadgl Auto Trains provided transportation throughout the fairgrounds. The enterprise earned more than $300,000 in nickels and dimes.

The Overfair Railway, which ran along the fairground's northern boundary, charged patrons 10¢ to travel its 2.5 miles of track; too few did so to make it profitable. The rolling stock survived the Exposition, and three of its locomotives now operate on the Sawnton Pacific Railroad 65 miles south of San Francisco. A fourth is displayed in the California State Railway Museum in Sacramento.

The Palace of Transportation included an exhibit of automobiles by some five dozen American manufacturers. There was a Packard twin-six with V-shaped engine; a Maxwell that converted into a sleeping car for camping trips; and vehicles manufactured by Cadillac, Pierce, Winton, Lozier, Locomobile, Hudson, Oakland, Hupmobile, Cole, Studebaker, Stanley, Franklin, REO, and Abbott. Only four of the 60 nameplates are made now.

Henry Ford's assembly plant in the Palace of Transportation became one of the Exposition's most popular exhibits. For three hours every afternoon, except Sunday, it produced new cars at the rate of one every ten minutes; all 4,338 sold out long before the fair closed.

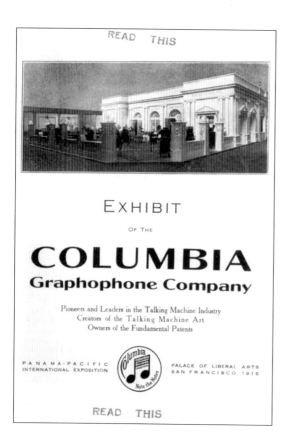

The Columbia Graphophone Company's exhibit in the Palace of Liberal Arts featured a behind-the-scenes demonstration of the steps in the making of records. It also displayed individual record ejectors, dictaphones, and player piano mechanisms. It was especially proud of its recording of "the entire opera of Aida," available on 17 two-sided 78s.

PANAMA-PACIFIC INTERNATIONAL EXPOSITION
1915 - SAN FRANCISCO - U.S.A.

COMMEMORATIVE COINS

AUTHORIZED BY ACT OF CONGRESS STRUCK AT SAN FRANCISCO MINT

ONE DOLLAR GOLD—Designs by Charles Keck
Issue limited to 25,000 pieces.
OBVERSE: Head representing Labor through whose efforts the Panama Canal became a reality. UNITED STATES OF ★ AMERICA ★ 1915
REVERSE: Two dolphins indicating the meeting of the two oceans. ONE DOLLAR ★ PANAMA-PACIFIC EXPOSITION ★ SAN FRANCISCO·

QUINTUPLE EAGLE ($50) GOLD
ROUND AND OCTAGONAL
DESIGNS BY ROBERT AITKEN
The first Fifty Dollar Gold Pieces to be issued under the authority of the United States. Total issue limited to 3,000 pieces.
The motives used in these designs were selected by the sculptor because of their simple dignity and far-reaching significance, as well as for their decorative pattern.

QUARTER EAGLE ($2½) GOLD—Designs by Charles E. Barber
Issue limited to 10,000 pieces.
OBVERSE: Columbia seated on the mythical Sea Horse, Columbia with the Caduceus, the emblem of trade and commerce, inviting the nations of the world to use the new way from Ocean to Ocean. PANAMA-PACIFIC EXPOSITION ★ 1915
REVERSE: American Eagle on a standard bearing the motto E PLURIBUS UNUM ★ UNITED STATES OF AMERICA ★ 2½ DOL.

HALF DOLLAR SILVER
DESIGNS BY CHARLES E. BARBER
Issue limited to 200,000 pieces.
OBVERSE: Columbia scattering flowers; attendant with cornucopia, to signify the boundless resources of the West. Background, Golden Gate illumined by the rays of the setting sun. PANAMA-PACIFIC EXPOSITION ★ 1915
REVERSE: Shield of the United States surmounted by American Eagle and supported on the one side by a branch of oak, emblem of strength and stability, and on the other side by the olive branch of peace. UNITED STATES OF AMERICA ★ HALF DOLLAR ★ IN GOD WE TRUST

OBVERSE: Minerva, the Goddess of Wisdom, Skill, Contemplation, Spinning, Weaving and of Agriculture and Horticulture. UNITED STATES · OF · AMERICA ★ FIFTY · DOLLARS ★ M·C·M·X·V· in field · IN GOD ★ WE TRUST·
REVERSE: Owl, sacred to Minerva, the accepted symbol of Wisdom, perched upon a branch of western pine. · PANAMA-PACIFIC · EXPOSITION ★ SAN FRANCISCO · In field · E ★ PLURIBUS ★ UNUM The Designer's initials, R. A.
Dolphins, suggesting as they encircle the central field, uninterrupted water route made possible by the Panama Canal, occupy the angles of the octagonal coin.

The U.S. Mint celebrated the Exposition with five different coins, all struck at San Francisco's branch mint facility at Fifth and Mission. All sold for double face value, except the $2.50 gold piece, which was $4. Discounts for multiple purchases, single sets, and double sets, with two of each coin to show obverse and reverse at once, also were for sale. Congress had authorized coinage on the fairgrounds, which would have been a first. Mint officials were concerned about security, however, and decided against it. No other American world's fair has been honored with so many different coins or with $50 gold pieces.



THE TOWER

12 feet square at the base a[nd]
Its graceful lines rise far...
rounding exhibits. It is ado[rned]
with axes mounted on a bl[ack]
ground—1,000 axes are used...
tractions of the tower are...
Ball on the top. Four large B[lades]
In the "Light House", Balco[ny]
trade of Handled Axes. Huge...
with three Faces, (Hands m...
and Spades). Westminster...
Chorus of Blacksmiths and dis...
State of California, (made ent[irely]
ware and mounted in a Heavy...

THE FOUNTAIN

The Fountain in the center
with its revolving Auger Bits...
Background and the Wire and...
a realistic representation of...
The illusion is so complete th[at]
glance it is difficult to realize...
water. To produce this effect...
Auger Bits revolving to giv[e]
water flowing from the uppe[r]
lower one. The copper basin is...
a Coal Oil Reading Lamp. T[he]
of the Fountain from which...
flows, is composed of a Machinis[t's]
Hose Nozzle. The center stream...
an Electrician's KEEN KUTTER Bit...
Car Bit; the Spray, 40 feet of...
and 75 feet of Jack Chain. T[here]
sists of 144 feet of Jack Chai[n]
duces the water effect. The c...
Fountain are 30 Bicycle Wren[ches]

THE ANGELS.

In the Corners above the Col[umns]
ures of Angels, proclaiming...
KEEN KUTTER Tools and Cutlery. T[he]
long and decorated entirely wit[h]
Hardware. The Wings are of Bu[ck]
Table Knives and Spoons. Tru[mpets]
Electricians' Bit Extensions...
Pointers on ends. Hair is of...
Armlets are of small Brass Buf[f]
ture Nails. Drapery on skirts...
Jack Chain; Waists—white back[ground]
—yellow background. 482 item[s]
in these figures.

THE CORNICE.

The Cornice is made entirely...
Tools and contains 618 items...
KEEN KUTTER Trade Mark in center is...
10 feet high, on a black backg[round]
Rules on a red background. Tape...
on yellow background. Handles...
Grass Hooks and Screw Drivers...
Handles of Chisels in the natur[al]

(Designed and constructed by...
Britt, who has been continu[ously]
employ of the Simmons Hardw[are Com-]
pany] for more than thirty-s[ix...]

SIMMONS HARDWARE COMPANY'S EXHIBIT at the Panama-Pacific International Exposition—Manufacturers' Palace.

Exhibitors used every imaginable means to promote their wares. Among others, Keen Kutter's moving blades exhibit impressed fairgoer Laura Ingalls Wilder, who wrote her husband about it. "Above . . . was an arch made of glistening spoons of different sizes. At the upper right-hand corner was a gigantic pocket knife with four blades that kept opening and shutting and at the upper left-hand corner was a row of seven blacksmiths standing each at his anvil with a different tool in his hand," she informed him. "At stated times first one and then another would beat the tool on the anvil with his hammer. . . . At the center top were two windmills made of ax blades continually turning." Others displays spun, circled, twirled, bounced, and boomed. More than 1,500 different postcards were produced for the fair by commercial publishers, promoters, and exhibitors—more by far than for any world's fair, domestic or foreign; Keen Kutter's, a mammoth 7$^1/_2$ by 10 inches, is the rarest of all.

The Palace of Fine Arts marked the western end of the great exhibition halls. The large lagoon hosted both swans and celebrations, including this "Fairy Fleet" from Hawaii. Being on Presidio property, the buildings evaded destruction when the exposition ended. In 1927, the city received the land from the Army in exchange for the railroad right of way along Marina Boulevard.

North, south, and west of the Palace of Fine Arts, fairgoers found the Exposition's second distinct area, home to state buildings and the pavilions of foreign nations. Here, looking west on the Esplanade toward the Massachusetts Building (center left), were the buildings of New York; Pennsylvania, its flag aloft; New York City, the only city to have its own; Illinois; and Ohio.

No state building ever erected for an American exposition has been larger than California's showcase for the PPIE. Taking Old Mission architecture to exuberant proportions, it was 700 feet long and 350 feet wide, enclosing almost seven acres of floor space. The beautiful cypress trees that shaded its paths and patio previously had done so for Herman's Harbor View Park.

The California Building hosted most of the receptions, banquets, and formal occasions of the Exposition itself, including this Grand Ball, given by the National Exposition Commission, for United States Vice President Marshall.

The Exposition's most warmly welcomed guest was the Liberty Bell. Initially, Philadelphia declined to provide it, but undeterred San Franciscans campaigned vigorously for the old icon. A petition was sent from the school children of California, containing tens of thousands of signatures. Flowered and feted upon arrival, the bell took up residence in Pennsylvania Building until the fair closed. Since returning home, it has not left Philadelphia again.

When The Great War began in Europe in August 1914, some wanted to cancel the fair, but the Board decided to open as planned. Although Britain, Germany, and others withdrew their participation, France remained. So captivated were San Franciscans that they recreated the French Pavilion, shown here, for a museum in Lincoln Park. This constituted a replica of a replica of the Palace of the Legion of Honor in Paris.

West of the state and foreign pavilions, the Exposition's third distinct area contained facilities for animals, athletics, aviation, and racing. The livestock exhibits had huge attendance, especially when they included such favorites as Farceur, the world's champion Belgian stallion. In 1917, C.G. Good of Iowa paid $47,000 for the privilege of providing him with free barn and board.

Because occasions like the Livestock Day Parade, seen here, proved so popular, local business leaders hoped to build a permanent place for them on the fairgrounds. In 1925, they formed the San Francisco Exposition Company to raise money for their enterprise. The group eventually received an appropriation of $250,000 from the state legislature in 1931, but by then the Great Depression made the whole idea seem contemptuous. "Why, when people are starving," asked a local newspaper, "should money be spent on a 'palace for cows?' " Ultimately, through a Works Progress Administration program, construction of the facility gave work to hundreds of unemployed people, but when the Cow Palace finally opened in 1941, it wasn't in the Marina District.

MAYOR ROLFE OLDFIELD GOV. JOHNSON

The Exposition's International Grand Prix was the first major automotive race held in San Francisco. Almost 100,000 spectators filled the seven grandstands along the racecourse, which used the streets of both the fairgrounds and the adjoining neighborhood. Barney Oldfield, here with Mayor Rolph and Governor Johnson, was the most famous entrant, but finished out of the money.

Driving a 5.6-liter Peugeot, Dario Resta completed the 400 mile, rain-soaked, and extremely muddy Grand Prix course in 7 hours, 7 minutes, and 57 seconds, averaging a little over 56 miles an hour. Howard Wilcox, driving a Stutz, was second. Resta also took the Exposition's other important race, the 300-mile Vanderbilt Cup, averaging 67.5 miles per hour on a dry course. In 1916, he won the Indianapolis 500.

The fair held twice daily aeronautic shows. Pilots mostly used the lawn of the North Gardens—now the Marina Green—to takeoff and land. Those daring or deranged enough (opinions varied) could experience flight for themselves in a hydro-aeroplane owned by two local brothers, Allan and Malcolm Loughhead, who in 1916 started what became Lockheed Martin, now the world's largest defense contractor.

Following Lincoln Beachy's death, Art Smith became the premier aerial daredevil. His side dips, somersaults, and other death-defying feats both astonished and stunned fairgoers, especially when he performed them at night. After the fair closed, the north lawn, renamed Marina Field, became the City's first municipal airport. There being neither airlines nor air mail for several more years, its use was sporadic.

Inventions displayed included these "moving picture machines." Exhibitors made such extensive use of film that some advertised, "No pictures of any kind—neither moving pictures nor stereopticon—will be shown." Film, however, was the medium of the future, which D.W. Griffith demonstrated in 1915 with his hugely controversial, explicitly racist *The Birth of a Nation*. The director hired many of the fair's artisans to construct sets for his next film, *Intolerance*.

Exquisite Audrey Munson posed for most of the female figures sculpted for the fair, including Calder's sublime *Star Maidens*; she also modeled for many of the women seen in the Exposition's murals. In 1915's *Inspiration*, she achieved screen immortality as the first actress in an American film to undress completely on screen.

The Exposition hosted the first transcontinental telephone call when Alexander Graham Bell in New York rang Thomas Watson, third from the left, at the fairgrounds on January 25. Installation was completed early, so the event took place before opening day. Fairgoers marveled at their ability to hear the Atlantic Ocean through a receiver in San Francisco. By 1915, Americans were averaging 40 phone calls a year.

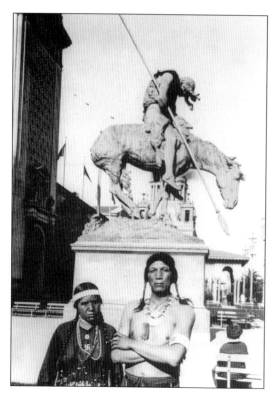

James Earle Fraser created the fair's most famous sculpture, *The End of the Trail*; unauthorized copies went on sale within weeks of opening day. It was balanced by Solon Borglum's *The Pioneer*, a work—and a pairing—now largely forgotten, which portrayed an old man, equally exhausted from the "subjugation of the Wilderness." Here, Iroquois Chief American-Big-Tree, the man who posed for Fraser's statue, poses with his likeness.

The Joy Zone, the fair's fourth distinct area, was an appropriate anarchy of architectural styles, adorned with every conceivable element of flim-flammery. Running along a broad avenue parallel to Chestnut from Van Ness to Fillmore, it had theaters, thrill rides, native villages, restaurants, kiosks, and souvenir stands. Not everyone was amused by the immense suffragette in front of *Toyland Grown-up*.

Seen here in this west-looking view from the Aeroscope, the Zone offered attractions of the highest moral caliber. This was partly because of political pressure by such groups as the Law Enforcement League and the state's exposition commission. The National Exposition Commission, appointed by President Wilson, restrained itself to the fair's foreign relations. FIn 1920, meeting in San Francisco's new Exposition Auditorium, the Democrats nominated Commissioner Franklin Roosevelt for vice president.

Even before the moral lobbying, many of the Zone's attractions strived to be educational. There were exhibits about the Panama Canal, seen here; the Grand Canyon; Yellowstone Park; and the Battle of Gettysburg, among many others. Most weren't successful and many closed early. Of the fair's more than 450 concessions, on the Zone and elsewhere, only 15 grossed more than $100,000 for the season.

The Dayton Flood closed after a few months of low patronage, possibly because San Franciscans, having just survived an earthquake and a fire, felt no need to experience additional devastation. It was replaced by a large painting of Spain's Escorial, 45 feet wide and 35 feet tall. Except for a few months in Madrid in 1914, it had last been exhibited in 1830. At the fair, it attracted some 200,000 visitors.

To prevent mischief and misbehavior, the selfless saviors of other people's propriety tried to end the sale of alcohol on the fairgrounds and to censor the less elevated exhibits. They eventually closed the '49 *Camp*, but they couldn't stop *Stella*, the finely detailed portrait of a woman who seemed alive, thanks to careful lighting and a simulated breathing effect. About 750,000 fairgoers, mostly men, paid 10¢ each to behold her.

The *Aeroscope* lifted patrons several hundred feet into the air for a spectacular view of the grounds, the city, and the bay. Unfortunately, not enough visitors enjoyed the ride for it to make a profit. It was built by Joseph Strauss, whose masterwork would be the Golden Gate Bridge.

Both the Alligator Farm and the Ostrich Village performed poorly, but Captain Sigsbee, the Educated Horse, made money for his partners. Named for the Maine's commander when it blew up in Havana Harbor, the nine-year-old chestnut counted the people in the theater's front row, made change in small amounts, matched colors, and played show tunes on a set of musical bells. Audiences adored him.

The Exposition hosted named days every day it was open, sometimes honoring several counties, states, countries, people, or organizations on the same date. The grandest of these was San Francisco Day, Tuesday, November 2, when attendance reached 348,472. Only closing day a month later would attract a larger crowd.

For the first time, an American exposition made use of indirect lighting. Bulbs were hidden wherever possible. The Scintillator, at right, added to the pleasure, sending 48 beams of light high into the night air and fog in 7 different colors; many believed the display could be seen from space, possibly with dire consequences. The power came from a locomotive engine bolted to a platform offshore.

Pyrotechnics also lit the night sky, weather permitting. Here they burst forth from and above the Yacht Harbor, which itself was brilliantly illuminated with a searchlight fixed upon the Column of Progress from dusk until closing.

Closing Day, December 4, 1915, was attended by 459,022 people, then the largest public gathering ever seen in the western United States. Fairgoers flooded every part of the grounds, including the Zone, *above*. Approaching midnight, the lights of the fair went slowly out, the last of them lingering on the figure of Descending Night, *below*, in the Court of the Universe. Buglers high up in the Tower of Jewels played Taps. People left reluctantly, some after four o'clock in the morning. There was no vandalism to anything, even though everyone present knew all of it would be demolished.

The dismantling of the Exposition began the Monday after it closed. Except for the sculpture and the murals, almost everything—furniture, fixtures, equipment, artifacts, structures—was available to the highest bidder. What couldn't be sold was salvaged; what couldn't be salvaged was burned or buried.

Public Auction

Furniture, Furnishings Draperies, Desks Automobiles, Etc.

New York State Building

Panama-Pacific International Exposition

Monday, December 6th, at 11 a. m.
and following days

NORMAN E. MACK, Chairman JOHN R. YALE, Vice-Chairman
DAN'L L. RYAN, Secretary New York State Commission

H. TAYLOR CURTIS, *Auctioneer*

In what could be called the Graveyard of the Gods, the figures of the fair await their future. Almost none of the sculpture survived the demolition, but the maquettes were saved. Placed into some 200 crates, they were stored in the basement of Exposition Auditorium until 1934, when all of them were given to the Park Commission. No one knows where they are today.

So dies that far magnificence of light,
A conquered splendor on a crumbling pyre,
'Mid fall of crimson temples from their height,
And ruined altars yielding up their fire.
—George Sterling, *The Evanescent City*

Above, the *Nations of the East* and the *Arch of the Rising Sun* meet their fate. Below, a tower at the entrance to the Court of Palms crashes to ground.

Unlike the statuary, the fair's murals were carefully removed and preserved. The Exposition Company presented 37 of them to the War Memorial Board of Trustees, which installed Frank Brangwyn's panels in the new Herbst Theater, where they remain on display. Frank du Mond's *Pioneers Leaving the East* and *Pioneers Arriving in the West*, part of which is seen here, were installed the old Public Library, but didn't move to the new facility; they were removed in 1996 and are no longer exhibited. *The Season of Fruits* by San Franciscan Florence Lundborg, famed for her cover illustrations and posters for *The Lark*, currently is in storage. Childe Hassam's *Fruit and Flowers* went on long-term loan to the Fine Arts Museums of San Francisco, where it is also in storage. Most of the other murals have not been seen by the public since the exposition closed, and none is displayed on the former fairgrounds.

With the grounds finally cleared, the land was restored to at least its original condition. The Exposition created a public dump at Lobos Square, then used other sites nearby. To finish the landfill, the city brought in a suction dredge to pump more mud from the bottom of the Bay. The work of wrecking and restoration was completed by February 1917.

The segment of the #22 Fillmore's route between Broadway and Marina Boulevard offered breathtaking views of the Marina District and San Francisco Bay. Northbound streetcar service ended at Broadway. There passengers boarded the line's unique counterbalance cars for the trip down Fillmore Hill.

Four
A New Neighborhood

With the exhibition closed and its debris moved, burned, or buried, the fair's board of directors returned to its owners 76 city blocks of graded land suitable for subdivision and development. Thanks to the PPIE, the district had streetcar service on both Chestnut and Van Ness for the first time. Harbor View, previously a working-class neighborhood with factories and warehouses, now would become a prosperous, planned residential community.

After a great deal of negotiation, Mrs. Virginia Fair Vanderbilt sold the 55 acres she owned in Harbor View to a real estate development consortium, who wanted to build a new neighborhood on it. The group called the area the Marina-Vanderbilt Tract, but the name didn't stick. Earlier attempts by other real estate people to name it Golden Gate Valley, then Exposition Valley, never took hold either. Marina Gardens for a time seemed a real possibility, but eventually the area became known simply as the Marina District.

The developers subdivided the tract into half-acre parcels for an envisioned planned community of single family homes, each set amid large lawns and lush gardens. Early buyers, though, found it much more profitable to further subdivide their parcels into standard 25 foot lots or to build apartment houses instead.

Ultimately, only one part of the developers' original plan was implemented: a non-traditional grid pattern for the neighborhood's streets. No one attempted to restore the area's previous grid pattern, which had been obliterated by the Exposition.

By 1920, 14 years after the earthquake and fire, San Francisco was a modern, thoroughly rebuilt city, although it still lacked many current landmarks. The Marina District, cleared of the exposition, had yet to receive its streets, but everything else seemed in place for the rapid development of San Francisco's newest neighborhood.

Thanks to the PPIE, the land purchased by the Marina's developers was filled, flat, and vacant. Only the north lawn—purchased by the City from the Exposition Company in 1921 for $204,750—the yacht harbor, the Column of Progress, above, and the Palace of Fine Arts, below, remained from the Exposition; the tracks in the foreground belong to the State Belt Railroad. Soon the column, too, would be gone. Its location became the intersection of Marina Boulevard and Scott Street, which sealed its fate. So many motorists misjudged the monument's whereabouts that the City declared it—not them—a driving hazard and had it removed.

The Marina's developers put streets in swiftly. Not quite done with its task in the spring of 1924, a steamroller rests in the left center of the photograph. The man nearby gives a human proportion to the work. The huge palm trees are leftovers from the fair.

A few months later, the streets were in place, with a restored Lobos Square, the Column of Progress, and the Palace of Fine Arts all part of the new grid pattern.

Brokers wasted no time putting up their "for sale" signs, but sales were slow at first. Meyer Brothers made the first purchase: a two-block parcel bordered by Pierce, Scott, Chestnut, and Alhambra. Most buyers built apartments on their property. By the 1930s, they had completed the majority of the neighborhood's rental units and many of its homes.

Neighborhood services developed faster than the neighborhood itself. The American Trust Company opened an office in the district in 1922, and the Bank of America in 1927. The Metropolitan Theater came in 1924, followed by the Marina Theater in 1928. By the end of the decade, residents could shop at Shumate's Pharmacy, the Great Western Grocery Company, and many other stores.

The Municipal Railway's F Line, begun for the Panama-Pacific Exposition, continued after the fair closed. In the fall of 1916, the outer terminal was extended from Chestnut and Laguna to Chestnut and Scott. Here, Car 48 is about to roll through the intersection of Chestnut and Pierce on a lovely day in 1925, with another streetcar just behind it.

On November 16, 1921, a cable-electric car on the Fillmore Hill counterbalance line ran away while traveling downhill, crashing into buildings and power poles before making a spectacular, unscheduled stop between Green and Union.

It was August 25, 1929 when residents of the Marina District witnessed the Graf Zeppelin arrive from Tokyo on its way around the world. Although seen by some as superior to airplanes, within less than 10 years the dirigibles had flown their last commercial routes.

Many of the residences on Marina Boulevard had been built by 1930, although the landscaping hadn't necessarily taken hold yet. Automobiles were no longer a novelty, but many people were still casual about parking them. Painted lanes, meters, and no parking zones would come later.

The Great Depression didn't end improvements to the neighborhood. One major project was rebuilding James Fair's old seawall. The federal Works Progress Administration provided funds; the state Emergency Relief Administration provided expertise; and San Francisco provided materials—cobblestones, then being replaced on the City's streets with other paving material. Most had come here as ballast on sailing ships in the late 1800s.

The Yacht Harbor, popular from its opening day, has been home to all kinds of craft, from cabin cruisers to steam yachts to row boats. Its also has been home to the physical education program of the city's high schools that offered rowing. For which school these oarsmen rowed in this c. 1930s image is now unknown.

The deteriorating Palace of Fine Arts, now city property, was renovated in the late 1930s. The Park and Recreation Department then installed 18 tennis courts in what had been the painting and sculpture galleries of the PPIE not 20 years before.

Marina Junior High School opened in 1936 with facilities for 1,200 students. Beginning in the early 1940s, however, many landlords in the area decided to rent only to couples without young children. In less than 10 years, the neighborhood had a large middle school with few students. High school students living in the Marina District traveled out of the neighborhood, although not very far.

Residents of the Marina District watched the construction of the Golden Gate Bridge from their living room windows or strolled along the Marina Green to get a closer look. They could see up-close parts of the bridge, such as this elegant tower corner, before they were installed. Planners estimated that the new span, compared to ferry transportation, would save commuters almost an hour per round trip.

The two main approaches to the bridge bracketed the Marina District, merging behind the Palace of Fine Arts. The Redwood Grove Theater at Crissy Field became the reviewing stands for the parades that celebrated the bridge's completion. Parking was available on either side of the theatre. A lone motel opened on Lombard in the 1940s; many more joined it in the next decade.

During the period of bridge construction, the Pan American China Clipper began transpacific service to Asia. The flag spread out on Marina Green saluted the plane when it passed over the City on the first segment of its 7,982-mile inaugural flight to Manila on November 22, 1935.

From the rising towers of the Golden Gate Bridge, workers had a stunning view of the Marina District—and a great deal more. In the years since the bridge opened, few have been privileged to experience in person exactly the same panorama.

The Citizens of San Francisco and
the Redwood Empire Counties of California

request the honor of your presence

to witness the ceremonies at the opening of the

Golden Gate Bridge

and the attendant

Fiesta

San Francisco, May twenty-seventh to June second

Nineteen hundred and thirty-seven

Angelo J. Rossi
Mayor of San Francisco

To mark the completion of the Golden Gate Bridge, San Franciscans celebrated with a seven-day fiesta, including pageants, regattas, a Wild West show, a championship pistol shoot, swimming races, fireworks, a grand costume ball, and a '49er fandango.

The festivities of the Bridge Fiesta began May 27 with a parade that was the first of three to be held in honor of the bridge's completion. Motorcades, bands, floats, and followers began at Van Ness and Union, zigzagged west and north to Marina Boulevard, then west to Crissy Field, where they passed in review before the crowds in the Redwood Grove Theater's grandstand. The 16th Battalion Canadian Scottish Regiment, seen here—"the Laddies from Hell"— participated on the first day.

No parade in those days was complete without a festival queen, and the Bridge Fiesta had many. Here they are at the Redwood Grove Theater, which was specially built for the celebration. This theatre also hosted three presentations of *The Span of Gold: A Pageant of the Golden Gate Bridge*. The spectacle retold the story of the Bay Area from the earliest Native American residents to California statehood. Tickets were $2 and $1.

The day before vehicles could drive across it, the public was invited to "walk the bridge." Parking was available at Crissy Field, but many participants chose to ride the Fillmore counterbalance line to the goings on. Usually uncrowded, the line had its best week since the 1915 exposition. The bridge walk was an all-day event. The Bay Area now was home to the world's longest single-span suspension bridge, which was also the only bridge to span the entrance to a major harbor. It joined the longest bridge spanning the largest major navigable body of water (the Bay Bridge); the world's largest vehicular tunnel through solid rock (Yerba Buena Tunnel); and the world's longest highway bridge and orthotropic span (the San Mateo Bridge).

By the end of the 1930s, the Marina had become one of San Francisco's "little cities within the city." Because so much was built within a ten-year span, the neighborhood developed an architectural unity, and its beautiful Mediterranean-style homes served as a perfect complement to its exquisite setting. The Marina added numerous additional shops and services during the

1930s, including a junior high school in 1936 and another theater, the El Presidio, in 1937. By the end of the decade, it was a fully formed community, and Chestnut Street provided for all the needs of most people's daily life. In one block of Chestnut alone, residents could find a drug store, a bakery, a magazine stand, a gift shop, a bank, a beauty salon, restaurants, and a cocktail lounge.

The counterbalance system on the Fillmore Street Hill was discontinued on April 5, 1941. Streetcar service now ended at Broadway and Fillmore, and motor coaches traveled the distance from there to Marina Boulevard. The San Francisco Municipal Railway took the line over in 1944 from the Market Street Railway Company. Four years later, trolley coaches replaced the streetcars.

On their last day of service, two cable-electric cars of the Fillmore Street Hill line pass each other in front of Marina Junior High School, while banners welcome their replacement, named the Marina Coach Line.

The William C. Ralston Memorial was dedicated on September 8, 1941. His daughters, Mrs. Arthur Page and Mrs. Bertha Ralston Bright, stand next to monument artist Haig Patigian. To their left are Park Commissioner J.J. Herman; Alfred Sutro; and Mayor Angelo Rossi. One of the 19th-century builders of the City, Ralston's epitaph reads, "He blazed the path for San Francisco's onward march to achievement and reason."

During World War II, the Army reacquired the Palace of Fine Arts, using it for a motor pool. It was returned to the city in 1947. For the next ten years, the galleries served many purposes, such as warehouse, telephone book distribution center, and fire department headquarters. By the mid-1950s, the buildings, built to last only a year, had deteriorated so much that their survival seemed impossible.

After considerable difficulties and setbacks, reconstruction of the Palace of Fine Arts finally began in 1964. The buildings, including the rotunda seen here, were stripped to their foundations; only the steel framework was retained. Given available funding, not everything could be replaced as it had been at the PPIE, so a modified, simpler design was used. The exterior work was essentially complete by 1967.

By 1950, with the war won and peacetime prosperity apparent, the Marina was a fully formed neighborhood of some 5,000 households, whose median income was about $4,400 a year. Although originally envisioned as an area of lavish homes on large lots, apartments outnumbered houses by more than three to one. The median rent was about $60 per month.

Streetcar service on Chestnut Street ended January 19, 1951. Electric buses replaced it, which many residents at the time felt gave the area "a more modern look." The tracks themselves came out during the 1950s. The road work disrupted both traffic and trade, and when business dropped as much as 90 percent in some stores, merchants appealed to the San Francisco Board of Supervisors to hasten the project.

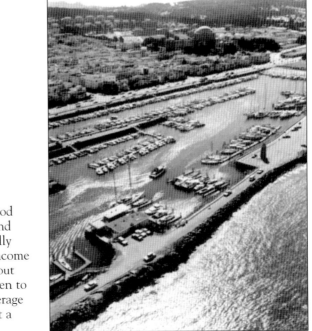

During the 1950s, with fixed and unmovable borders, the neighborhood added fewer than 150 new homes and apartments, so housing costs naturally rose. In 1960, the median annual income of Marina residents had reached about $5,900, but the median rent had risen to $104 per month—21 percent of average income compared to 16 percent just a decade earlier.

Although it had a cameo appearance in *Bullitt*, the Marina Safeway, built in the 1960s, achieved everlasting fame as the place where Mary Ann Singleton met Michael Toliver. Some consider the store the largest singles lounge in the world.

San Franciscans celebrated the golden anniversary of the Golden Gate Bridge with another bridge walk. So many people joined together on the span that they temporarily flattened out the bow of its deck. Souvenirs were plentiful, including a commemorative ticket similar to the one used in 1937.

The Marina District avoided serious damage during the Earthquake and Fire of 1906, but was struck with full force by 1989's Loma Prieta Earthquake. Four people died, seven buildings collapsed, another four were destroyed by fire, and the city declared 63 others unsafe to occupy or even enter. Lives and buildings in other parts of the City also suffered damage, some severe, but the Marina sustained the greatest destruction in San Francisco.

Liquefaction, amplified ground shaking, and structural design flaws all contributed to the devastation of the 1989 quake. Like many parts of San Francisco, the Marina's land was manufactured—the entire neighborhood is built on marshes and lagoons filled with sediment from the bottom of the bay. The types of surfaces include filled marsh land, beach sand, graded dune sand, and sedimentary deposits. The nearest surface bedrock is at Fort Mason.

The District's development began less than 20 years after the Great Earthquake and Fire of 1906, but geologic considerations didn't determine the location or the design of its dwellings. This scenario is not likely to happen again. The outward wounds of 1989 may have healed, but its lessons were well learned.

USA 20

SAN FRANCISCO, CA
JUNE
2
1997
94188

FIRST DAY OF ISSUE

Although the Golden Gate had appeared on two U.S. postage stamps and the Bay Bridge appeared on one noting its 10th anniversary, the Golden Gate Bridge wasn't so honored until its 60th anniversary in 1997, when it was depicted on two postal cards. The 20¢ card not only showed part of the span, but much of the Marina District as well.

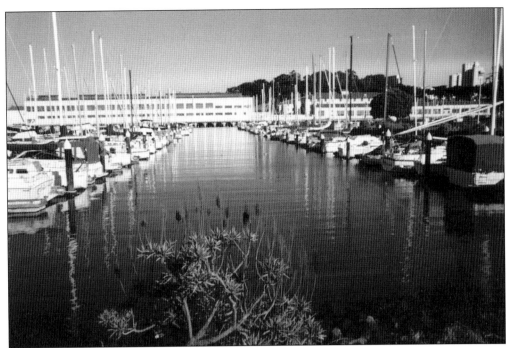

Today the north shore is fully utilized by strollers, joggers, rollerbladers, boaters, kite fliers, frisbee throwers, sun bathers, dog lovers, bird lovers, nature lovers, friends, paramours, and sweethearts of all ages. Denizens enjoy the art, crafts, food, and exhibitions at neighboring Fort Mason, exhibits at the Palace of Fine Arts, and events at Crissy Field and the Presidio.

Despite an innate need of park commission's everywhere to populate open places with statues and stelae, the Marina Green has resisted such efforts. After 60 years, the Ralston monument stands alone, although the flagpole at Marina and Casa is home to two plaques.

The yacht harbor is home to more than 700 vessels of many different types, the latest in a long list of craft that have sailed, steamed, rowed, or otherwise journeyed from the north shore into San Francisco Bay—and through the Golden Gate—for income or for enjoyment.

The Marina District's great beauty and stunning vistas are not only for neighbors and friends. They are for all San Franciscans—for all visitors to these shores—who wish to know the near and far horizons of our home.